BRITISH FIGURATIVE ART

British Figurative Art

PART TWO: SCULPTURE

Norbert Lynton

PHOTOGRAPHY BY

Adrian Flowers

momentum

First published in Great Britain in 1998 by
Momentum, P.O. Box 12752, London E8 3UA

ISBN 1 873362 83 8 (paper)
ISBN 1 873362 84 6 (cased)

A catalogue record for this book is available from the British Library

Co-ordinated by Ben Lawrence and Kate Leese
Designed by Peter Gladwin

Printed in London by The Pale Green Press

Flowers East
199 – 205 Richmond Road
London E8 3NJ
Telephone 0181- 985 3333
Facsimile 0181- 985 0067

BRITISH FIGURATIVE SCULPTURE

Visitors to this exhibition will have an advantage over me. I must write about it without having seen it. How will it look? If this wide-ranging but necessarily limited anthology of current and recent British sculpture has a message for us, what can or will that message be? The last four decades have seen the word 'sculpture' thrown into doubt by being made to accommodate activities and productions way beyond the reach of its etymology and previous use. There comes a point when words cease to be useful, and this could now be the case here.[1]

You will see about forty objects, made out of many materials and by a great variety of means. All of them are the work - one piece each - of professional artists living and working now. That means men and women of widely differing ages, from Lynn Chadwick, born in 1914, to Don Brown born in 1962. Most of them specialise in sculpture, but a few of them do not. There is good precedent for painters doing sculpture in a substantial way and with important results, think particularly of Picasso, Matisse and Degas, but then it is only a modern assumption that artists are likely to be committed to one art form or another. Michaelangelo was a sculptor who was led to work as painter and as architect by demand. Bernini, son of a sculptor, and a sculptor of amazing powers himself, is important to us also as architect. In this exhibition William Turnbull is seen as a sculptor; I also admire his work as a painter. Anthony Green is a well-known painter whose analytical interest in how we remember, and especially in how memory reforms visual material, has led him to structure paintings unconventionally and, recently, three-dimensionally, so that some have become free-standing things that can be called sculpture. Maggi Hambling's vivid ways of drawing and painting have found sculptural extensions in her cast bronzes. Neil Jeffries' constructed sculptures, represented here by a wall piece, are graphic images enacting legible scenes and situations. How these are constructed is very much a part of what we see, but they should not be labelled constructivism.[2] Lee Grandjean's piece here is one of the few carvings on show. That is certainly part of its statement, yet a compelling part of it must be his own head in profile, apparently painted on to the carving but in fact made by charring the surface of the timber. The slab of wood that is his basic material leans against the wall rather like an unhung painting. In demanding what we might think an inartistic position, it also asserts its presence as an object, as though waiting to be accorded its validating position, and thus questioning that sort of accommodation. Many of the sculptures here need the traditional visual and psychological support of a base; others reaffirm the more recent tradition of not wanting any sort of reserved positioning. The sculptor who gave the new tradition its main impulse in Britain, Anthony Caro, famous from the start of the 1950s for his abstract metal constructions set not on a pedestal but on the floor, is represented here by a portrait bust that looks as though it came from the preceding decade but doesn't.

In 1983, having for twenty years and more witnessed the continuing enlargement of its range, I wrote that 'sculpture is what sculptors do'; any closer definition, I felt, would hold only for a moment if at all and thus would seem prescriptive.[3] I am to this day more interested in what artists

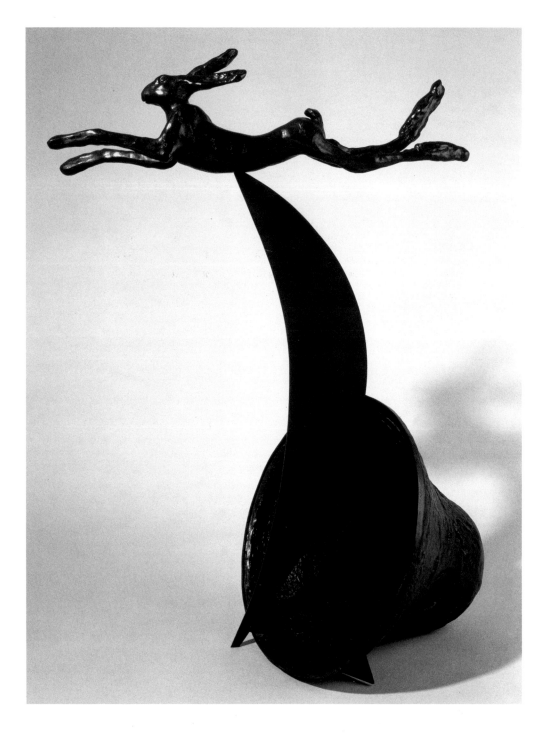

BARRY FLANAGAN

MUSICAL HARE ON A CRESCENT & BELL 1991
bronze
edition 8
134.5 × 97.5 × 64.5 cms
courtesy: Theo Waddington Fine Art

do than in how definitions may usefully contain it. This exhibition, so various in what it displays while limited in what it can or seeks to display, yet demonstrating so many paths towards as well as within sculpture, shows talented, thinking and feeling, individual artists inventing as well as echoing and developing ideas and forms as sculpture, and using many ways of fashioning these sculptural objects.

None of them is very large, but they are almost all the size they are meant to be: just one is a maquette for something realised on a larger scale, and that is Eduardo Paolozzi's *Maquette for the British Library (Newton after Blake)*. The exhibition's title says they are all 'figurative'. We know by now to take a broad view of what the word can embrace. A few exhibits occupy the borderland in which modern painting has often operated, where figuration and abstract form meet. In any case, for artists the figurative/abstract division ceased to be significant long ago. What has evidently remained significant is the modern attitude to how and to what ends materials are used. 'Truth to materials' used to be the watch-word: show how you engaged with the wood or stone you were carving and let the nature of that particular piece of wood or stone speak through the sculpture's formal expression. (A comparable doctrine operated in painting, asserting the flatness of a picture as something to be conveyed rather than negated, and requiring the means of painting, the tools and paint itself as colour and texture, to be a great part of what was conveyed and valued.) The slogan is not heard today and its ethical implications seem to have melted away, perhaps because now it seems generally the way of sculptors to announce the physical reality of what they do rather than to hide it. The sculptors of the classical tradition used to be praised for their skill in persuading us that they had overcome technical problems and had succeeded in turning stone into living flesh - even when the stone was marble of a whiteness never found in flesh, living or dead. This did indeed call for skill in the carver: close knowledge of both flesh and of marble, while in the viewer it called for a suspension of disbelief that now seems both foolish and difficult to relearn. It went with attending first and foremost to the subject and theme of the work: e.g. subject: naked woman, theme: Venus or Eve or peasant girl with pails, or whatever.

Roger Fry is in the critical stocks these days for stressing the role of form over that of subject-matter, of what his friend Clive Bell had called 'significant form', meaning form that had a marked aesthetic character and was neither done nor intended to be read as merely an account of something existing elsewhere in other materials, whether nature's work or mankind's. By the time Fry died, in 1934, he had qualified that emphasis considerably. In any case, it needed making when he made it, to compensate for an attention to narrative or description that was both too exclusive and too automatic. In the process he opened our eyes, artists' as well as the public's, to the beauties and energies of non-western or non-fine or non-high kinds of art, mostly carvings of a sort then called primitive. Fry never claimed that subject matter had no role at all. Today, when we do not demand realism in art (which means that realism is available again as a radical option), the argument can be dropped. We are used to receiving two and three-dimensional artistic form as being significant in itself without needing to avert our attention from subject-matter, whether or not it echoes what people call visual reality. It is one of the virtues of an assembly such as this one that you can ask, and perhaps judge, how form and subject-matter are now balanced.

In the 1960s, we used to be told, art became predominantly abstract and then, in the 1970s, conceptual. Of course, it didn't, but in so far as abstract art had mostly put its eggs in the basket marked 'form' (though Abstract Expressionists laboured not to be seen as formalist) and conceptual art used the basket marked 'ideas', the two tendencies certainly sharpened artists' abilities to work with, and our ability to respond to, both. In fact, the baskets turned out to be one basket approached from different directions, and we need no longer force ourselves to distinguish between them. The demise of that artificial polarity is likely to be one of the messages conveyed here.

Another relates to the issue of sculpture as object. Scarcely had modern art got used to the notion of sculpture as a self-sufficient thing, as opposed to being wholly or primarily an imitation of something else, when the whole tradition of art being objects came under attack. Art galleries had become powerful centres for marketing these objects and there were more artists making more such objects than ever before, when the word went out that supplying this market implied servitude to capitalist priorities with which many artists felt uncomfortable, especially young ones kept out of it by those already well placed in it. Making art that did not fit it, and could serve to mock it, became an honourable and persuasive strategy. From this partial aversion from commerce (partial because artists still have to find a way of living and financing their activities) and from a growing awareness of our responsibility for the future of this planet, came important ventures such as Richard Long's *Circle in the Andes*, 1972, a ring of stones arranged on a high plateau and photographed by the artist, and Barry Flanagan's installation piece in 'The New Art' at the Hayward Gallery the same year, of bits and pieces placed around a large space, mostly on the floor, and flanked by mirrors so that they 'confused focus almost to the point of agoraphobia'.[4] The late 1960s had seen a climax in what was sometimes called 'Performance Art'. Serious artists such as Stuart Brisley in the 1960s invented and submitted themselves to extreme situations far removed from anything the art galleries wanted or had to offer; less serious ones responded by diverting us during the 1970s with ritualistic scenes or circus-like entertainments. In 1969-70 two young sculptors began to present samples of what became their joint life-as-sculpture when Gilbert and George performed their mime piece, *The Singing Sculpture*, to a recording of *Underneath the Arches*, first in two art schools, and then at Nigel Greenwood's temporary gallery in Chelsea.[5] (A 1991 performance was videoed an the Sonnabend Gallery in New York and this is now the standard way of showing the work, but it is a smoother, more studied, more up-market performance than the original.) In 1972 'The New Art' exhibition made us take account of a period of disconcertingly rapid change that had begun with the first display of a Caro construction in the 'New London Situation' show at the Marlborough New London Gallery in 1961 and in which Bryan Robertson's 'The New Generation' sculpture show at the Whitechapel had been a second milestone. In 1960 one might still have risked a definition of sculpture, though the one Peter Fuller offered, Rodin's 'the science of the bump and the hollow', always questionable, had long before ceased to serve. By 1972 plurality was in, and the world knew it. Only the media had not then learned to play their 'cutting edge' sport.

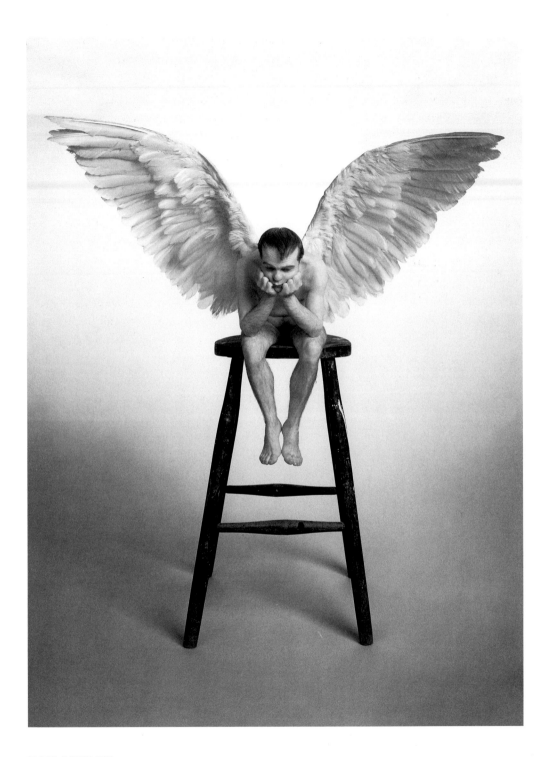

RON MUECK

ANGEL 1997
silicone rubber and mixed media
110 × 87 × 81 CMS
courtesy: The Saatchi Gallery, London

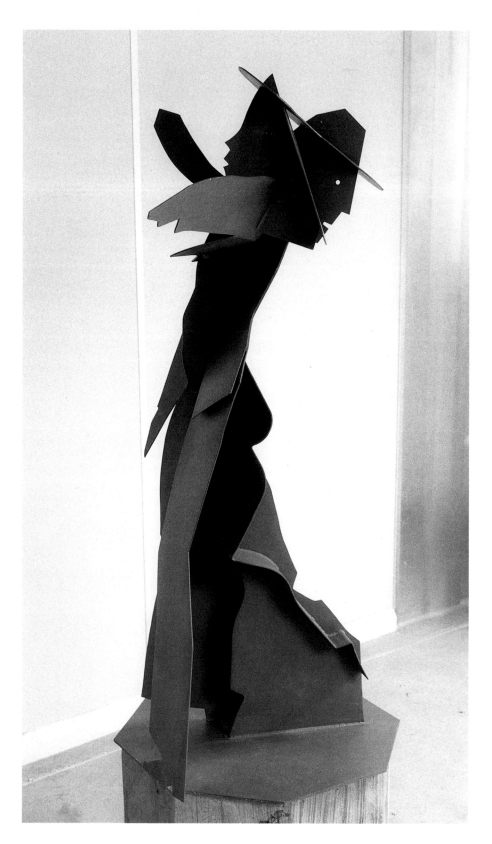

ALLEN JONES

LIVERPOOL DANCE 1984
steel and wood
150 × 99 × 66 CMS

The present exhibition is dedicated to sculptures that are single objects or delimited groups. All of them invite the name of 'sculpture'; that needs saying because all sorts of things have been named sculpture over the years, including photographs and inscriptions. Examples of these could have been included here but they are not: the aim was to demonstrate variety within the category of three-dimensional works created to be sculpture. We are invited to note the variety available at the best level of this art.

This variety comes at many levels. There is of course the material range, immediately apparent though greater than a first glance suggests. Chadwick's bronze figures on bronze steps, abstracted yet very much the slender creatures that haunt the fashion pages, are utterly different from Denise de Cordova's toy-like group, employing plastics and real baskets, closer to folk art in appearance, global rather than western, and at once we know that the difference is deeper than the choice of

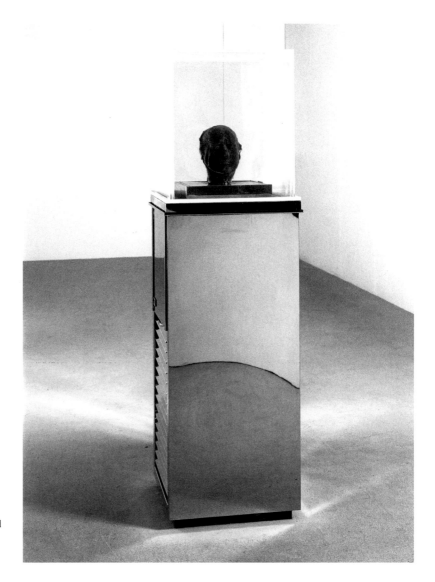

MARC QUINN

SELF 1991
blood, stainless steel, perspex and
refrigeration equipment
208 × 63 × 63 CMS
courtesy: The Saatchi Gallery, London

JAKE & DINOS CHAPMAN

BRING ME THE HEAD............ 1995
fibreglass and paint
27 × 20 × 33 CMS
private collection

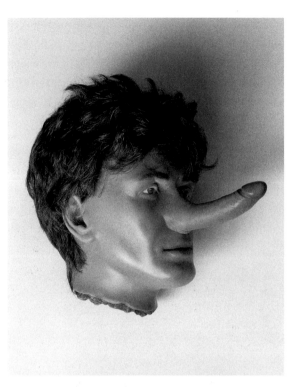

materials alone would suggest. Chadwick too used to experiment with new ways of making sculpture and materials not sanctified by history. Hambling's sculptures, a new venture for her in the 1990s, are drawn into and cast in sand before being turned from wax into bronze. Their slightness and the coarse textures left by the process - usually removed before a bronze sculpture is considered finished - contradict bronze's long-established image of power and permanence, and thus its traditional message of human authority. When we see that *Line* is a sequence, almost a rosary, of heads, our response is moved into another dimension, touching on basic relationships and fears. If we look then at Katherine Gili's *Aspen*, a welded steel construction, we find a sculpture of somewhat similar form: a linear sequence of small solids rising from one base plate to descend on to another, but wholly different in expression. Is it wholly different in theme? Asking the artist is not always the best way into what we call understanding (too often 'understanding' means quick labelling); we must allow our own responses to have their say. What struck me was that, because of the two base plates, Gili's sculpture strides where Hambling's hangs in space, one elegiac, the other dramatic and perhaps optimistic.

So already, meaning to speak again of materials, one is more or less forced to speak of affect, of what these works do to us, with and through the artist. Writing about Tim Lewis's work recently, and how he draws upon so wide a range of things as well as images and knowledge, Ann Elliott used the excellent phrase 'sorting out that world' and sees the process as an adventure.[6] The inference is that a vast world, hardware and software, lies in wait to prey upon the artist who, turning the tables, stalks this world. Artists specialised in mode and materials are confronted by an

infinity of possibilities every time they set out on a new work. Today, artists may see a particular configuration of materials as a temporary expedient, or move between procedures that are widely different, as Lewis does with his sometimes abstract kinetic pieces and his static sculptures in pewter, steel and wood. We may then wonder whether their underlying themes are continuous or whether they differ with the means chosen. Here that question is raised but cannot be answered in so far as each artist is represented by one work, but raising it is worth doing and the wealth of comparisons facilitated here throw light on it.

The question that is put more directly, and it is up to each of us to answer it on the basis of observation, is how materials bring meaning with them even when deployed by different artists. My Hambling/Gili comments scarcely touched on it, and to return to that pairing now is to be warned how complicated such questions are. Those two sculptures in metal, in bronze and in steel and thus necessarily a little different in appearance, are made very different indeed because of the contrasting visual character sought by the two artists. Hambling's *Line* is cast from a construction she made out of the wax forms cast in the hollows she drew into casting sand. Gili probably had an allover idea of what form her sculpture would take - she has been working in this way since the 1970s - but built it up gradually, cutting and joining pieces of steel to make the arched form she was after. Notice that both sculptures involved construction, but that in one this process is subsumed in the result while in the other it is part of its expression. Hambling's piece, I suggested, denies its bronze-ness; Gili's asserts its constructed steel character. Allen Jones makes flat forms that are then constructed in steel and angled against each to be read both flatly and spatially. His long-term theme is the meeting of genders in the class 'human being'; his view is that of the male. This used to draw attacks on him, as well as admiration, his use or abuse of woman as a male obsession. But it has long been obvious that his female images are so far removed from reality that he has been commenting on the artificiality this obsession takes on in the world. Moreover, he has long worked with male/female images, tending towards stereotypes but still charging them with human emotions. As he proceeds, he tests what his formal juxtapositions and elisions can do as three-dimensional metal structures and comes up with fresh solutions, while his theme remains more or less constant: not woman, not man and woman, but the denatured human being in its imagined interactions, stylised by centuries of idealisation and marketing, and here once again caught in the additional artifice of one moment in a dance.

Clearly we need our wits about us if we want to draw any conclusions from the interacting of mental and material factors. How wide a term 'figurative' has become has long been evident if, say, we take Rodin's *The Kiss* as self-evidently figurative and Braque and Picasso's cubism as still figurative rather than abstract. Here it is perhaps stretched to the limit. Grandjean's wood sculpture is hauled back into figuration by the presence of the silhouette. Turnbull's *Tall Balance* seems abstract but has something of a human presence about it and actually echoes a particular image of a man in the West Indies, 'walking along a beach [with] this long thin coffin balancing on his head'.[7] Eleanor Crook's male figure has the naturalistic specificity we associate with religious statues, especially images of suffering, with scientific models or with Madame Tussaud's portraits at their rare best. Crook's 'Harry' is utterly, painfully convincing, caught in every detail of face, hands

and feet but also with his skin and flesh sagging around his knees like a drunk's trousers so that his innards can hang out of his middle just above his externals. His colouration is rather pale, which links him back to the history of image-making and to the role of idealisation, but his jacket is entirely real, actual tweed. All of which may stop us noticing that he is too small to be at all real. And if we are haunted by old images of 'Christ at the Column' and other such affecting types, Crook has added a Glen Baxter-ish title to stop us in our nostalgic tracks. So her elaborately modelled figure eludes reality in appealing to it, just as we read Kenny Hunter's *Golden Calf* as a very realistic miniature replica of Aaron's idol as imagined by Poussin and other painters somewhat after the event related in *Exodus*. Only it lacks the one essential constituent of the original because it is not made of gold. The man with two trees in John Davies's sculpture is life-size. Davies had a vast success with his first show, at the Whitechapel in 1972, with thoroughly naturalistic clothed figures caught in dramatic situations. Since then he has worked with a variety of scales and at subtle distances from what we think lifelike looks like (have you noticed how readily we say that one photograph is not really like so-and-so whereas another catches him or her exactly?), so that his figures belong to the world of imaginings we actually spend a lot of time in but try to keep separate from 'reality'. They are made of fibreglass and painted, certainly not flesh and blood as Crook's almost made us think, but the trees are real in that they are tree stuff, branches, minus their bark.

Talking about life and naturalism necessarily makes us think of heads and portraits. Jane Ackroyd's head, *Full Moon*, belongs to the later history of cubism and has something of Gonzalez's excellent constructed metal heads about it. Glenys Barton's suavely flattened head in glazed ceramic adds vividly to the long history of sculptured heads since ancient times and recalls Renaissance subtleties of form and expression. It is so simple we could easily miss its essential refinements. Similar refinements give character to Bryan Kneale's *Clytemnestra*, a reference perhaps to the doom-laden character reappearing in Greek tragedies but here silenced, and again we meet naturalism conditioned by elisions and idealisation though the sculptor started from a specific living head. Caro's bronze portrait certainly started from a specific head, that of Clement Greenberg, the great but sometimes overweening American critic who taught us so much in the 1960s and 70s but is now often attacked as one who out-Fryed Fry. One admires Caro for portraying him when it was fashionable to condemn him. As sculpture this bust takes us back to the tradition of Rodin, of a naturalistic rendering in dark bronze of individual heads not only observed but also translated by the sculptor's hands into modelled objects revealing 'the science of the bump and the hollow'. In honouring Greenberg and Rodin, Caro demonstrates yet again his detachment from theories and rules, not least the rules he seemed to be steering by in the 1960s. It is vastly to his credit that the sculptor associated with full abstraction, with constructed metal sculptures with or without added colour, and 'real space', has for some years felt free to combine other materials with metal, to make sculptures that refer to figures as well as to figurative paintings, and thus to connect openly with subjects that touch us directly in human terms. He was an excellent modeller in the 1950s; he is evidently still an excellent modeller. I have not seen *Maggi*, Andrew Logan's portrait of Hambling, in photographs or in fact, but I have seen other Logan heads and figures. This one too is bound to bestride any fence we may want to put around sculpture and declaim its allegiance to the world of stage costumes and fancy dress. Peter Burke's head may or may not start from an individual person.

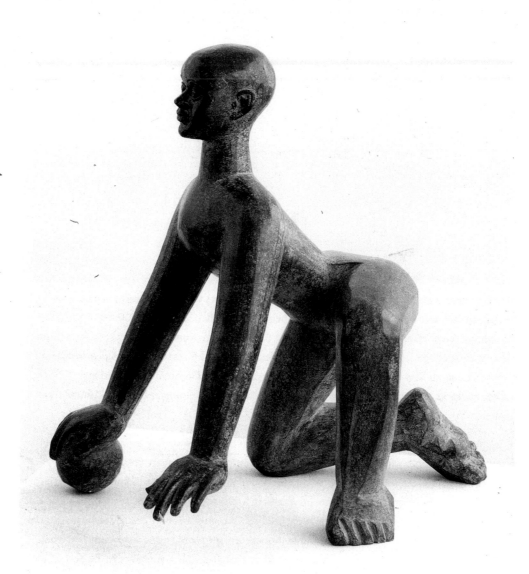

DHRUVA MISTRY

MOVING MOUNTAIN 1988/90
bronze
edition 5
38.7 × 25.2 × 38.9 CMS
courtesy: Anthony Wilkinson Gallery

FOOTNOTES

1. Not that we take much care of words when dealing with the arts. When people say 'art' they often mean painting, as in many a newspaper heading or caption referring to 'an exhibition of art and sculpture' or something of that sort. When they want to say 'sculpture' they often say 'statues' though, of course, a statue is a sculpture of a particular nature and size. They manage these things better abroad.

2. In order to distinguish the art that came out of it, thanks mainly to Tatlin, Gabo and Rodchenko, from the non-art productions and projects that were developed in post-Revolution Russia as constructivism (soon also known as productivism) and meant turning to inventing, designing and making useful and economically justifiable objects in a period of extreme shortages of materials and goods, I recommend the use of 'constructive art' for the former, as in *Circle, an international survey of constructive art*, edited by Gabo, Ben Nicholson and the architect J.L.Martin and published in 1937.

3. I was asked to write a booklet, *Looking at Sculpture*, to accompany 'The Sculpture Show' at the Hayward Gallery and the Serpentine Gallery that year and to partner the more formal catalogue of the exhibition. In his characteristically dismissive review of the exhibition as a whole and of everything in it, Peter Fuller had fun also with my not bothering to define the indefinable. The review, written for *Art Monthly*, was reprinted in his collection, *Images of God* (1985).

4. Anne Seymour, in the catalogue she wrote and edited for her epoch-making exhibition, presented by the Arts Council of Great Britain in 1972. 'The New Art' came in a sequence of biennial shows of contemporary British Art at the Hayward, selected by specially appointed small groups of artists and normally resulting in a more or less broad anthology of recent work in painting and sculpture. On this occasion the group concluded their initial discussions by handing the job to Anne Seymour, at that time an assistant keeper at the Tate Gallery, and she decided to produce a concentrated survey of British conceptual art, until then little seen and less noticed in this country but gaining fame abroad. The result, for all the care and intelligence with which it was presented, was met with a great deal of hostility. See Peter Spence, 'Narcissus 14; Echo 0', in *The New Humanist*, November 1972, for a thoughtful review that gave the exhibition a mixed reception but noted also the responses of the main newspaper art critics.

5. Since it is not mentioned in catalogues providing a supposedly complete list of Gilbert and George's work in many forms and media, I should like to record here that *Underneath the Arches* (its present name) was performed at Chelsea School of Art in 1969. Gilbert and George offered to perform their piece, speaking first to the sculpture school and then the painting school, and were rejected by both. They came to me in the history of art and general studies department, and we put it on. Many of the students and a few staff witnessed it; it took perhaps fifteen minutes in all. I was told off by the principal for wasting people's time and my department's money: £5. The other art school was the Slade.

6. Ann Elliott, 'The Mysteries of Matter', introduction to the catalogue of Tim Lewis's recent show at Flowers East, May/June 1998.

7. Quoted from 'William Turnbull in conversation with Colin Renfrew' in the catalogue of Turnbull's 1998 exhibition at the Waddington Galleries.

ANTONY GORMLEY

ANOTHER PLACE 1997
100 1.96m high cast iron body forms facing west over 3.5 kilometres of tide plain at the mouth of the Elbe river, Cuxhaven
courtesy: Jay Jopling, London

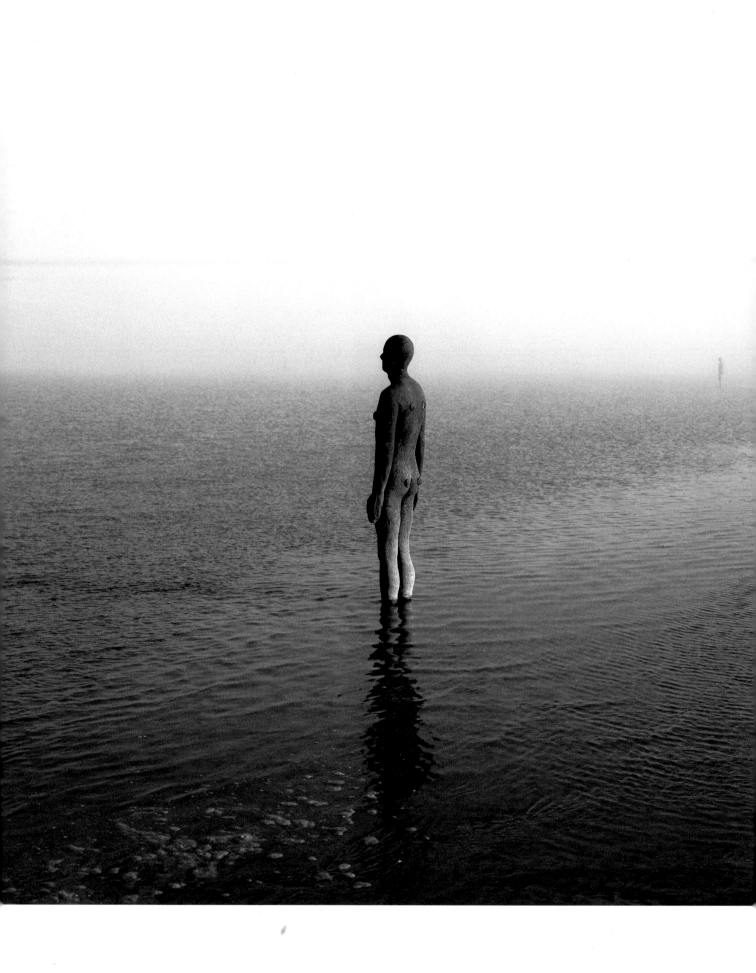

Points of view: an introduction to the photography

A visit to India was the source of two memorable quotes;

'Climb slowly and you'll climb to heaven'

'Sometimes in India it can take a very long time for something to happen suddenly'

They had the effect of sustaining me while I was trying to complete my contribution to this book. My own supplementary ideas both helped and hindered. 'Let's not do the usual – why not glimpses of the artist's?'

'Use black and white?' – why not – but sometimes colour is essential.

'Nothing too posed and no looking at the camera' – but when Caro smiled so sweetly how could I not go click?

Available light – also part of the concept – was available though very variable with the appalling weather. The discipline of intentionally rejecting reliable, controllable lighting was for me a special pleasure which will add to the inherent characteristics and extraordinary differences of these works and their makers.

Yet, do all these very individual sculptors have something in common? I would dare to suggest that they (and their works) have many different *points of view!*

Adrian Flowers
June 1998

All photographs by Adrian Flowers, except p6, p9, p11(Stephen White), p17, p19 (Helmut Kunde), p38, p59, p61, p79, p81, p85(courtesy: Manx National Heritage, p86-7. p89

IVOR ABRAHAMS

RHYTHMIC GYMNAST 1986

polychrome bronze
edition 6
45 × 25 × 49.5 CMS

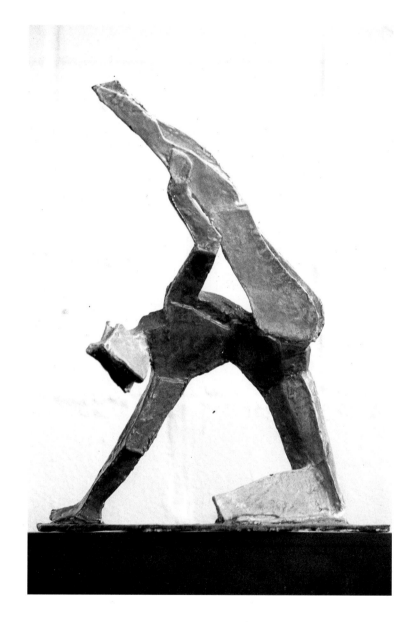

FULL MOON 1991

mild steel (to be cast in bronze)
edition 3
90 × 98 × 32 CMS

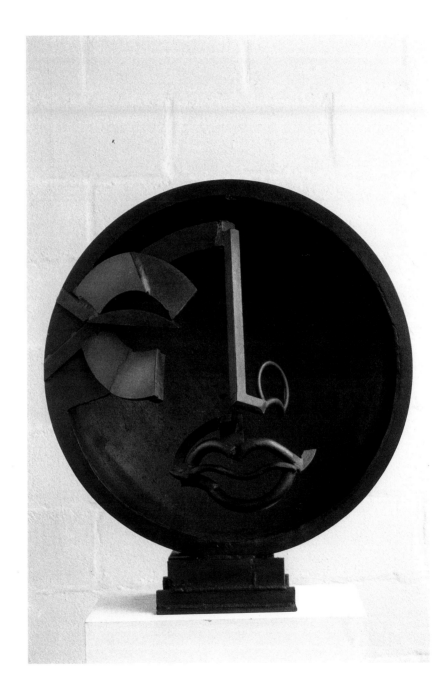

THE DAGDA 1994/96

cast aluminium with hand painting,
beechwood base
197 × 172.8 × 172.8 CMS

ALPHA & OMEGA 1998

ceramic
65.5 × 42 × 18 CMS

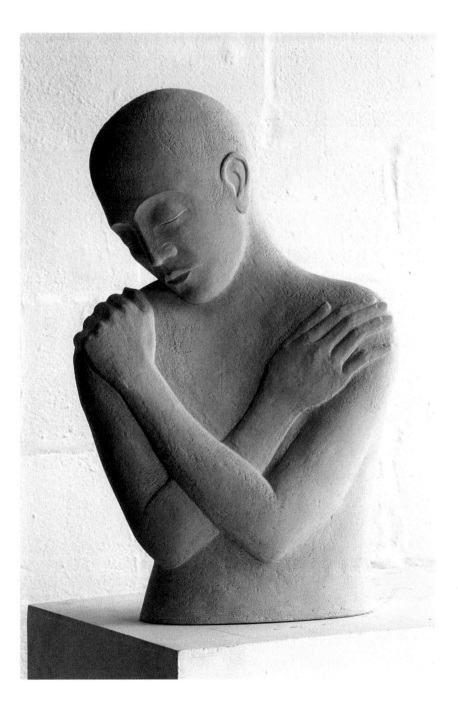

ZADOK BEN-DAVID

WALKING BACK 1997

mixed media
190 × 70 × 60 CMS

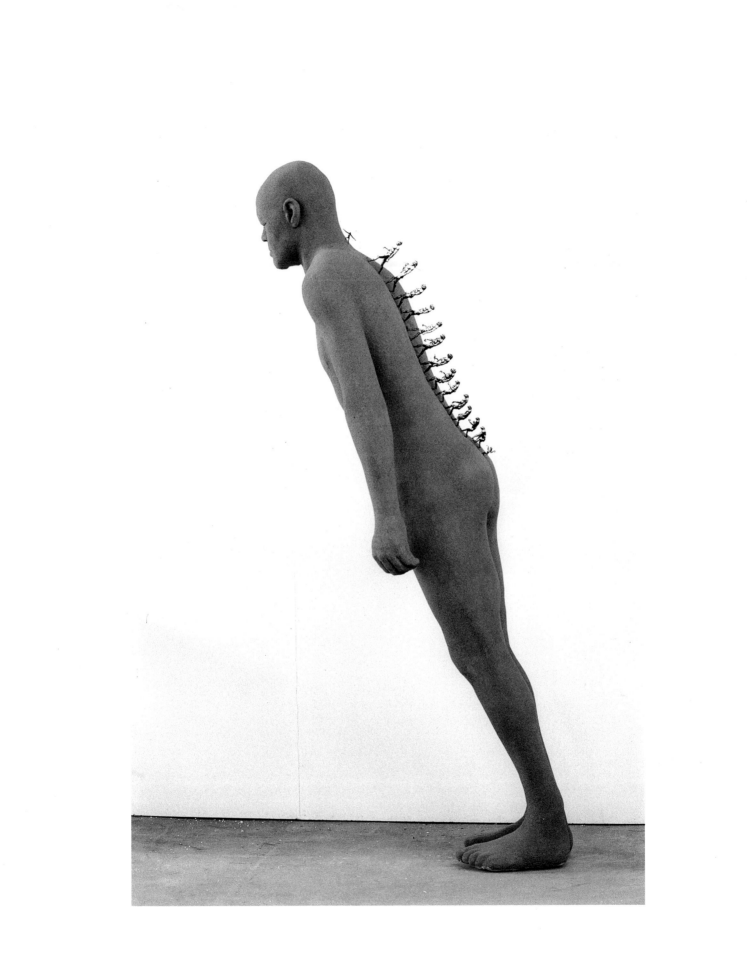

DON BROWN

SKULL 1998

plaster (to be cast in bronze)
edition 10
9 × 7 × 7 CMS
courtesy: Sadie Coles H.Q.

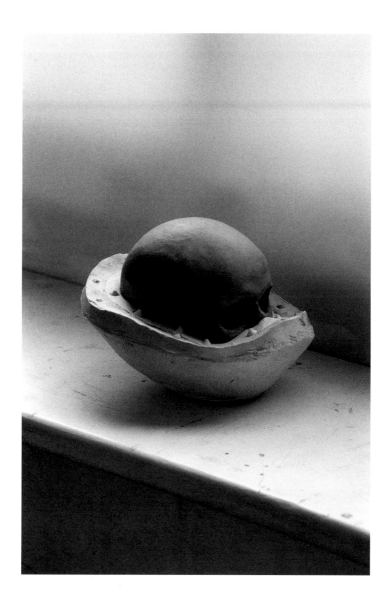

PETER BURKE

TABLE HEAD *detail* 1998

reclaimed steel
227 × 60 × 60 CMS

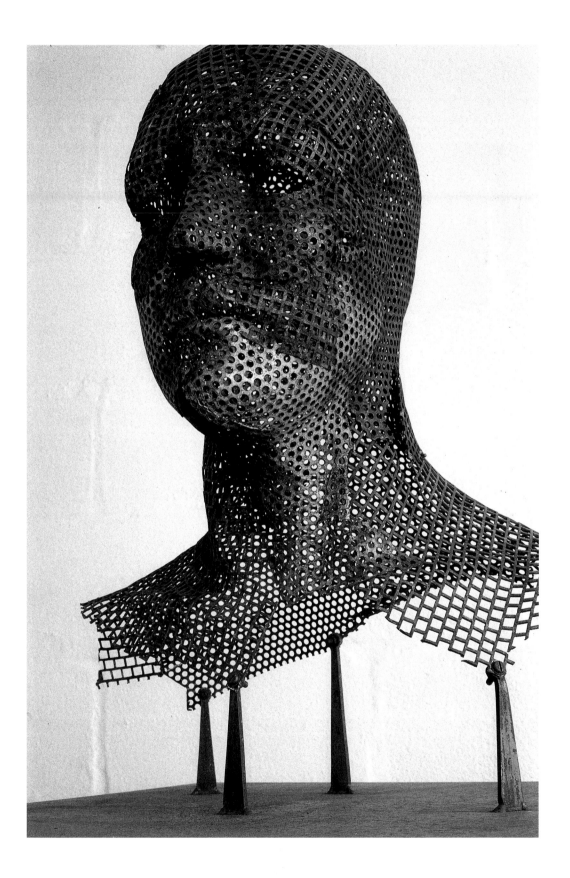

ANTHONY CARO

BUST OF CLEMENT GREENBERG 1987/88

bronze
edition 6
54.5 × 44.5 × 35.5 CMS
courtesy: Annely Juda Fine Art

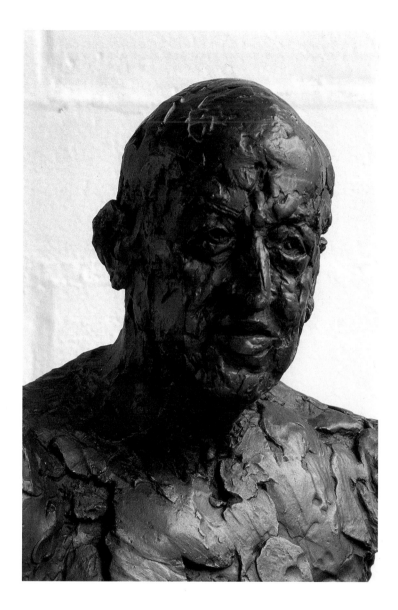

lynn Chadwick

STAIRS 1991

bronze
edition 9
105 × 53.2 × 37 CMS
courtesy: Berkeley Square Gallery

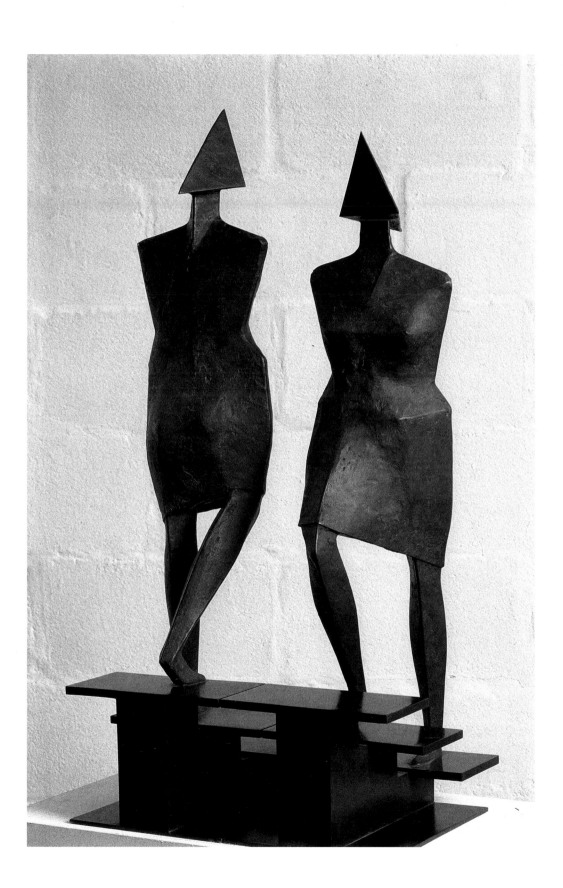

MARCUS CORNISH

STACKER 1993

brick clay
42 × 25.3 × 19 CMS

SAY 1997

imperial porphyry
42 × 14 × 7.5 CMS
courtesy: Michael Hue-Williams Fine Art

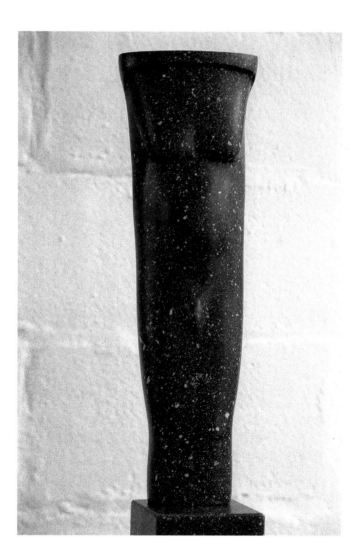

ELEANOR CROOK

HARRY HOPED I'D UNDERSTAND THAT MY INTEREST IN HIM
CAME AT AN INOPPORTUNE MOMENT 1998

wax and tweed
91 × 35.5 × 35.5 CMS

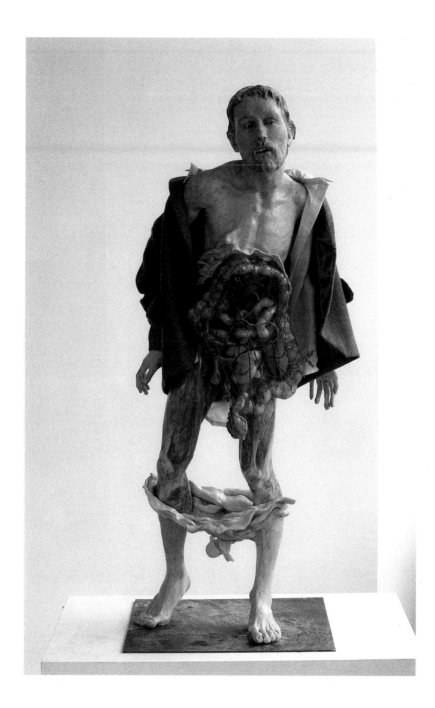

JOHN DAVIES

THRESHOLD FIGURE
(TWO TREES) *detail* 1994/97

painted fibreglass, resin and tree branches
274 × 197 × 77 CMS
courtesy: Marlborough Fine Art

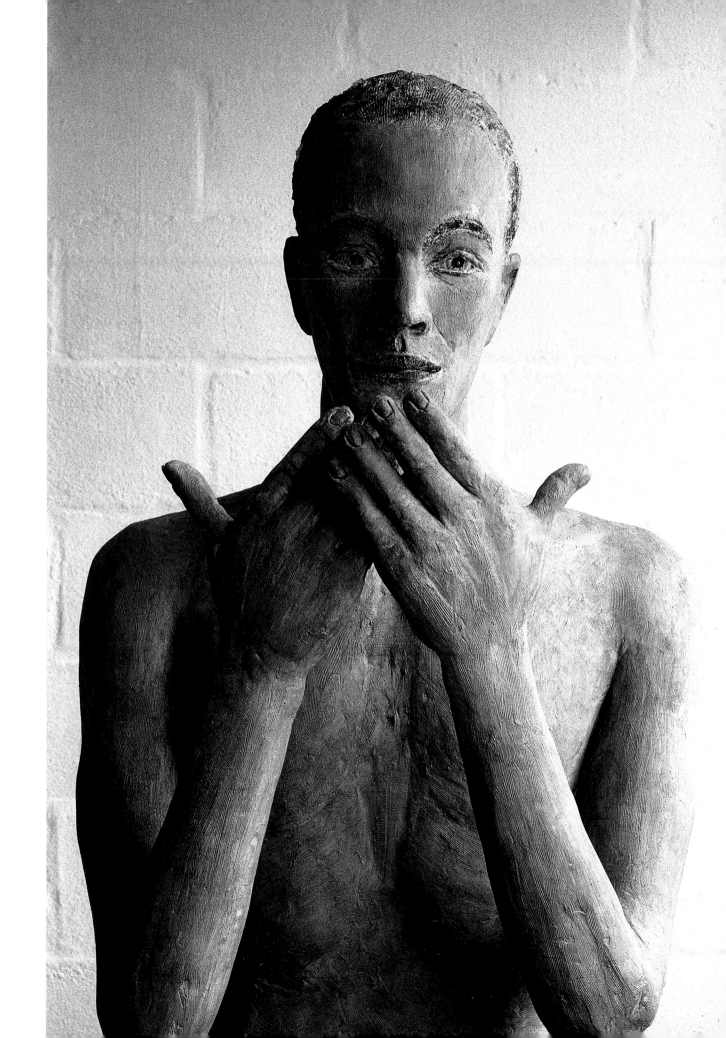

QUIET HERD 1998

mixed media
96 × 102 × 120 CMS

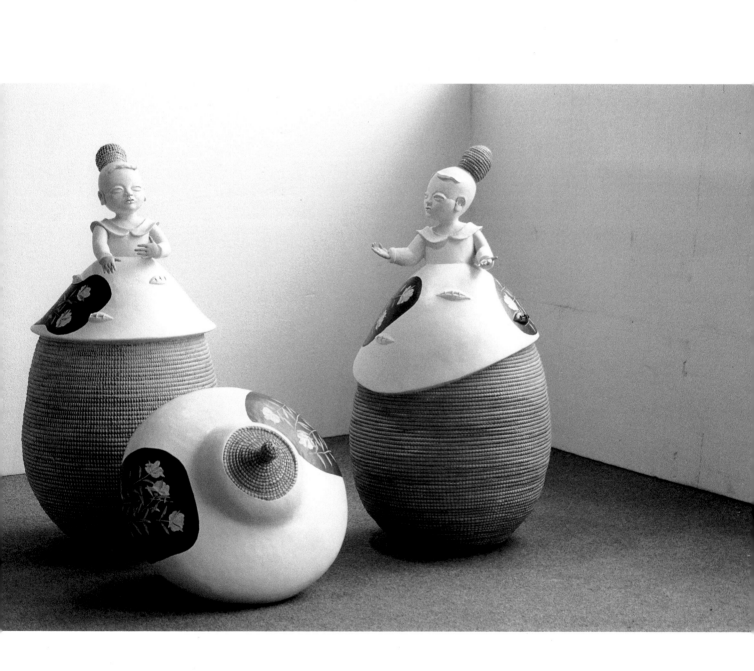

SOKARI DOUGLAS CAMP

ASSESSMENT 1998

mild steel, glass, oil, acetate and BOC goggles
246 × 115 × 69 CMS

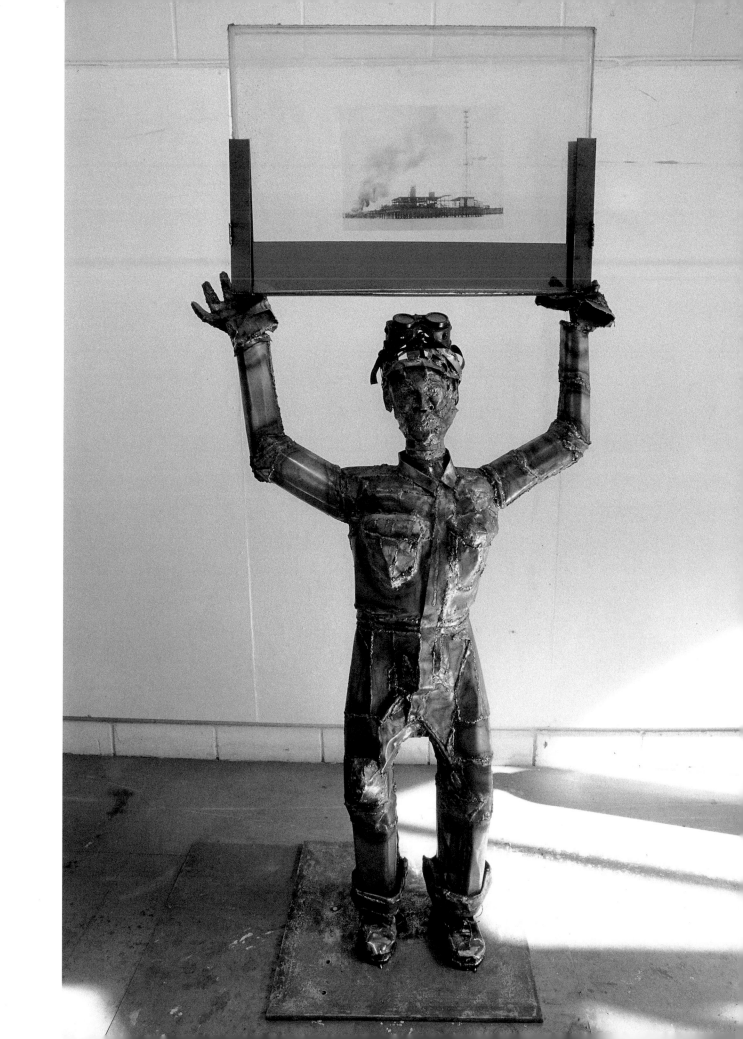

LAURA FORD

BANG BANG 1998

painted plaster and wool
105 × 90 × 60 CMS

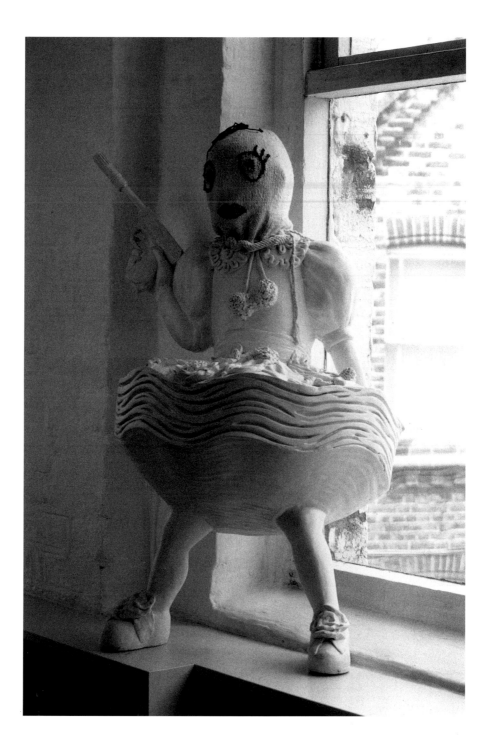

MAGGI HAMBLING

LINE 1995

bronze
180 × 43 × 38 cms
courtesy: Marlborough Fine Art

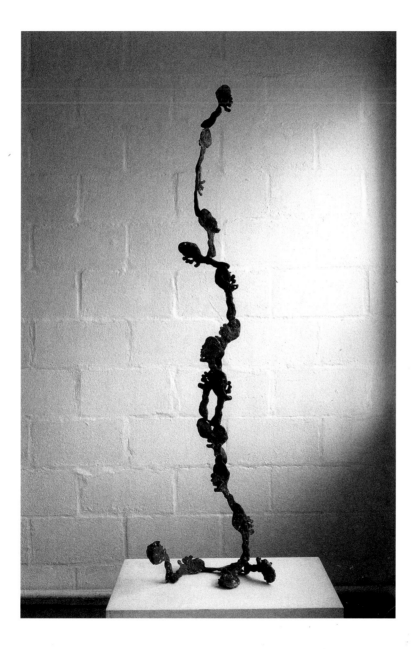

NICOLA HICKS

BULL WOMAN 1993

bronze
edition 6
160 × 65 × 75 CMS

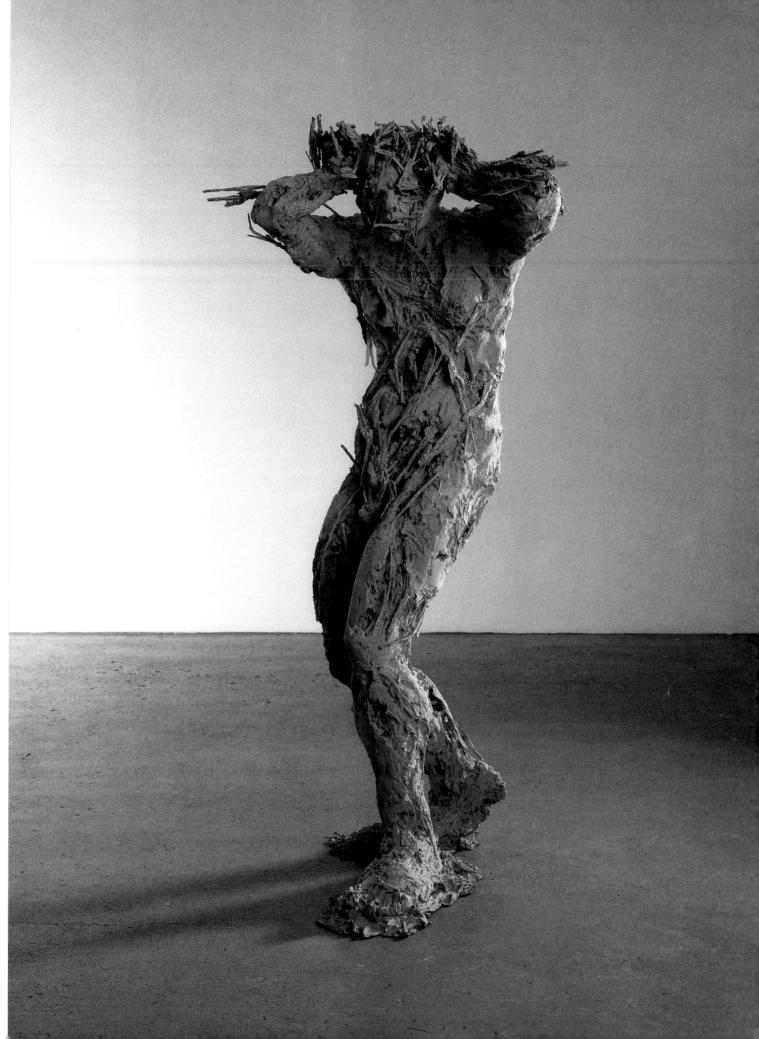

NEIL JEFFRIES

ANIMAL FROM A TAU CROSS
THAT I STRETCHED HORIZONTALLY 1998

oil on aluminium
76 × 148 × 39 CMS

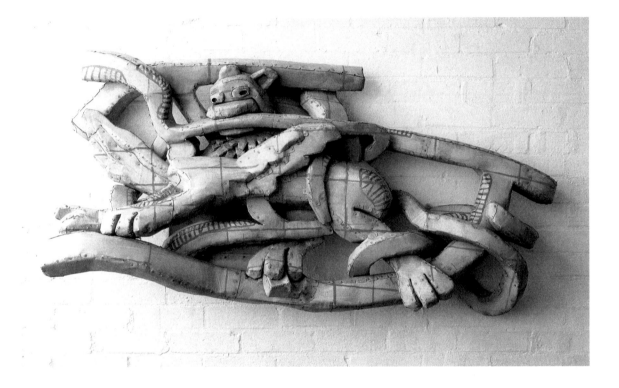

DAVE KING

HEAD OF THE INSTITUTE 1998

painted wood, steel, bronze
218.5 × 75 × 84 CMS
completed with the aid of research funding from Coventry University

UBU'S CAMEL 1989

bronze
edition 6
54.5 × 73.5 × 45 CMS

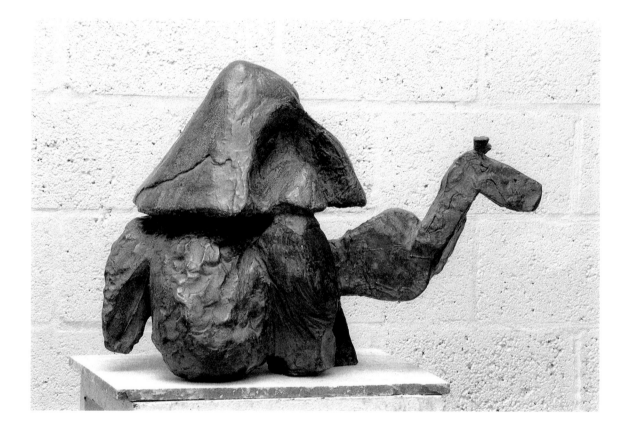

BRYAN KNEALE

CLYTEMNESTRA 1986

bronze
edition 8
37 × 21 × 24 CMS

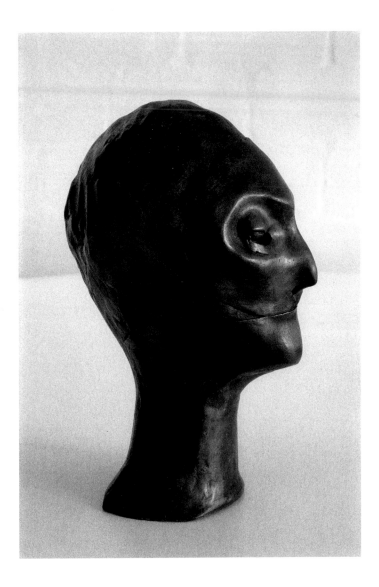

MAGGI HAMBLING 1998

glass and clay
160 × 61 × 46 CMS *including base*

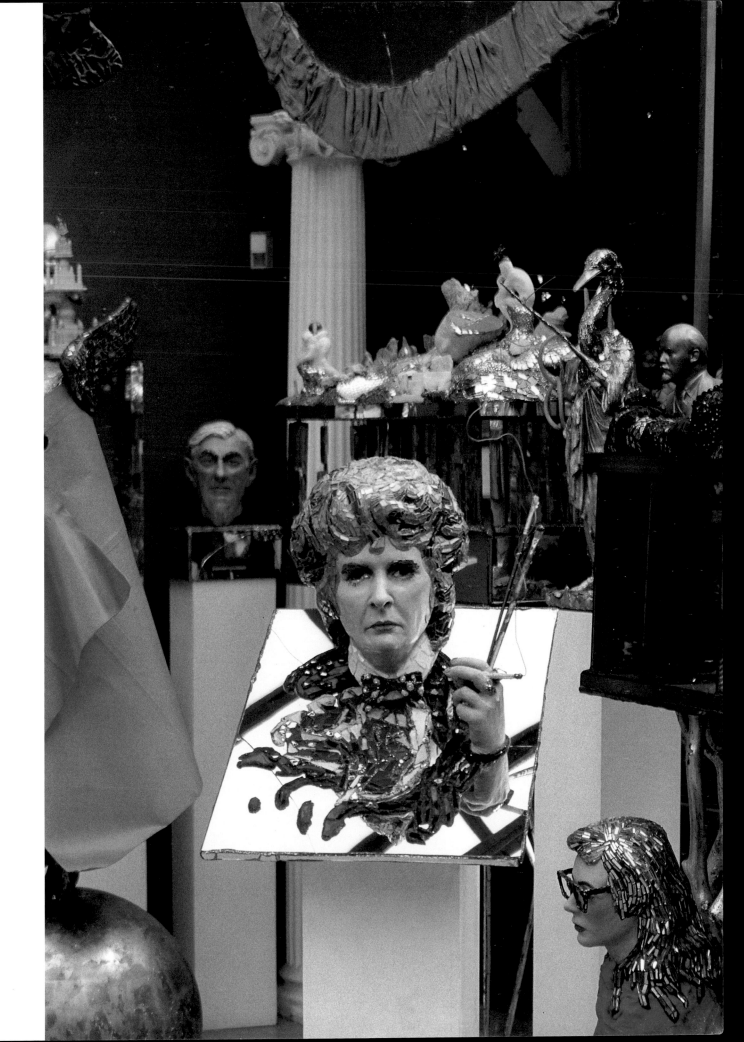

DAVID MACH

GARGOYLE 1994

fibreglass and sound system
183 × 122 × 122 CMS
courtesy: Jill George Gallery

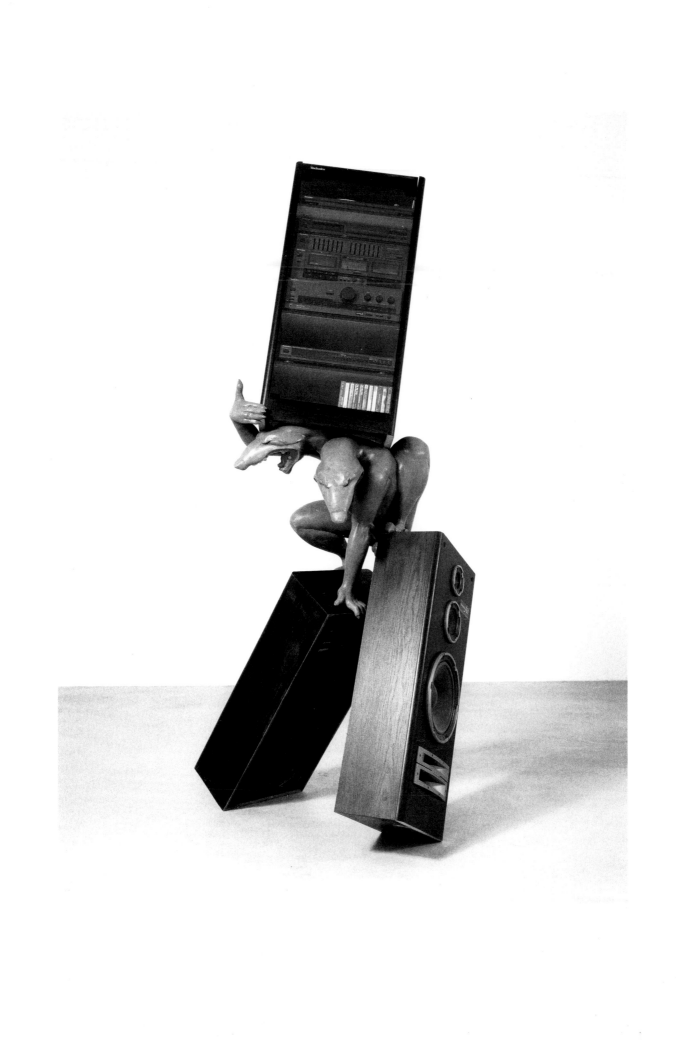

EDUARDO PAOLOZZI

MAQUETTE FOR THE BRITISH LIBRARY 1997
(NEWTON AFTER BLAKE)

bronze
edition 3
34.2 × 40.7 × 25.4 CMS

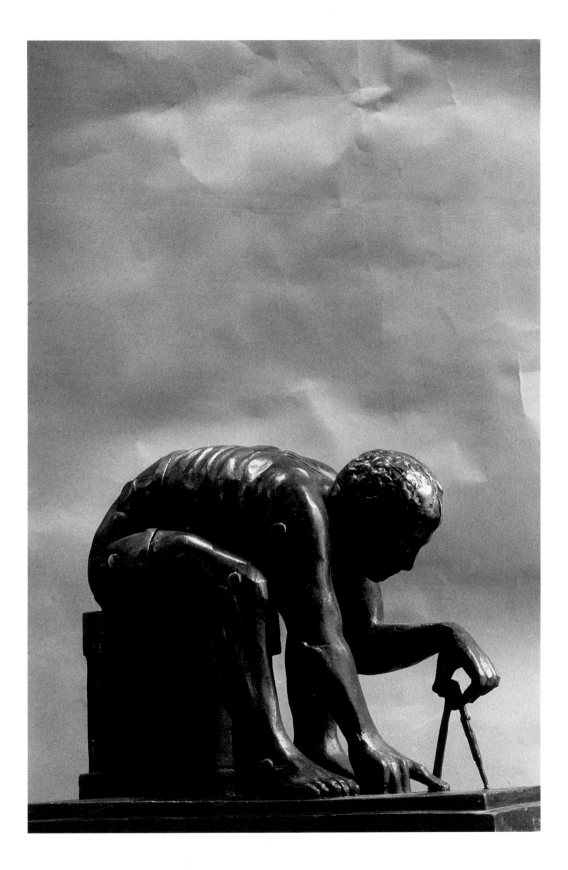

MICHAEL SANDLE

MAHNMAL 1998

bronze
edition 6
130 × 100 × 35 CMS

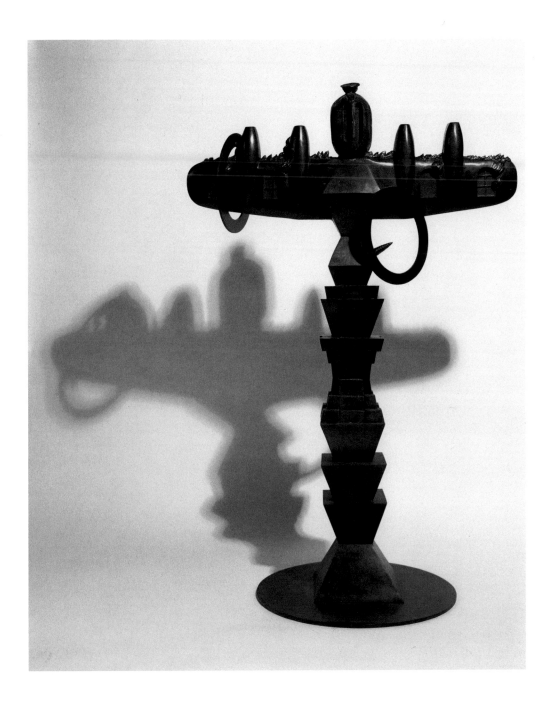

WILLIAM TUCKER

PRIZE FIGHTER (BIBI) 1998

plaster
38 × 29.2 × 31.8 CMS

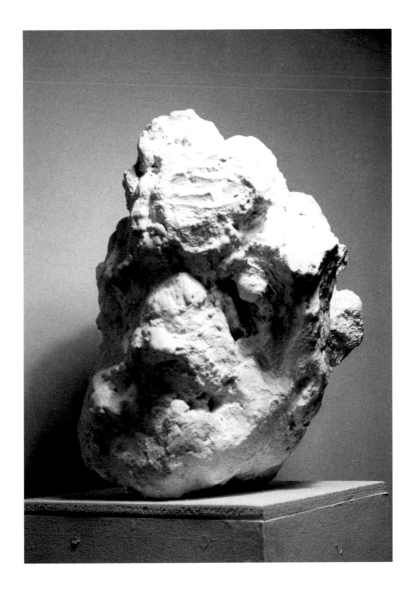

WILLIAM TURNBULL

TALL BALANCE 1992

bronze
edition 6
155.6 × 180.4 × 28 CMS
courtesy: Waddington Galleries

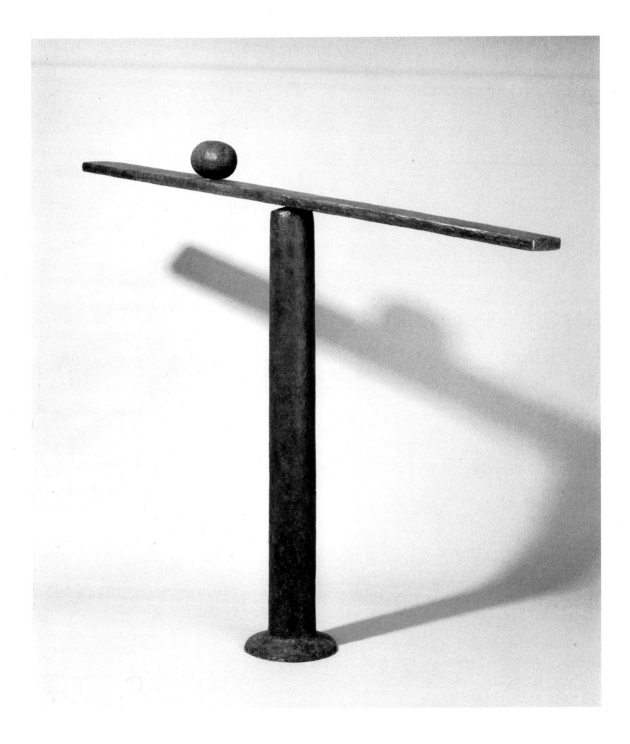

GLYNN WILLIAMS

TWO GIRLS FROM 1907
(AFTER PICASSO) NO. 2 1992

bronze
edition 3
188 × 61 × 61 CMS
courtesy: Bernard Jacobson Gallery

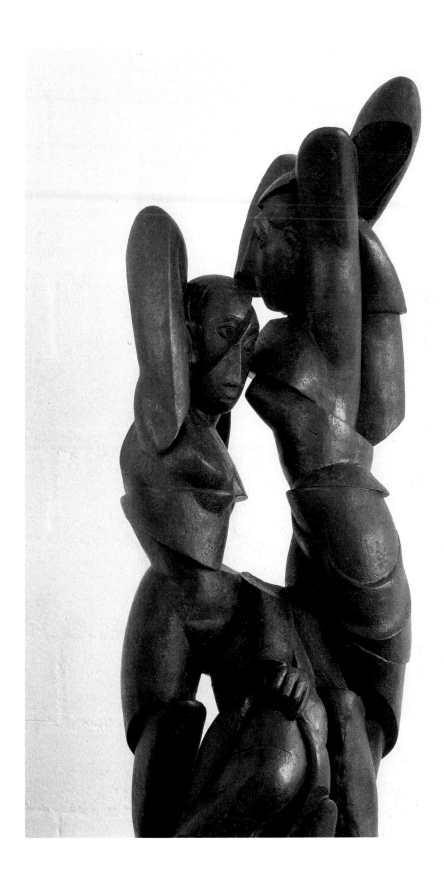